THE MOLA DESIGN BOOK

by Caren Caraway

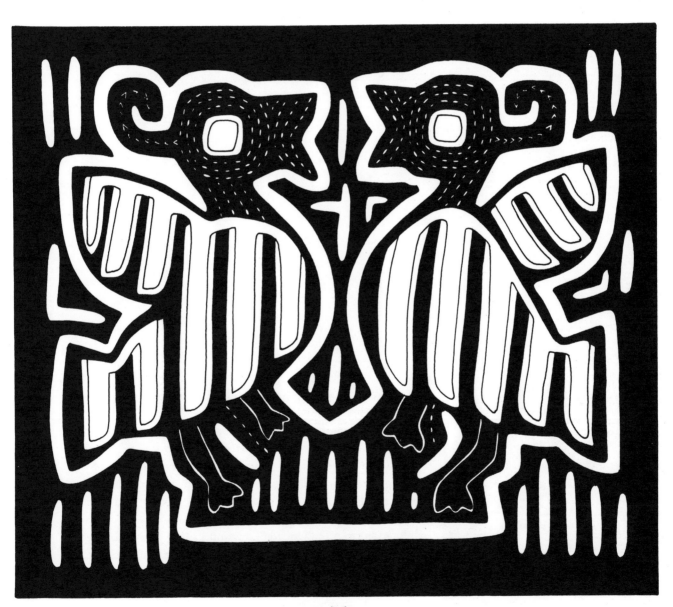

Stemmer
House
Publishers

4 White Brook Road
Gilsum, NH 03448

Inquires should be directed to:
Stemmer House Publishers, Inc.
4 White Brook Road
Gilsum, NH 03448

A Barbara Holdridge Book
Printed and bound in the United States of America

First Printing, 1981
Second Printing, 1986
Third Printing, 1990
Fourth Printing, 1994
Fifth Printing, 1997
Sixth Printing, 2001
Seventh Printing, 2005
Eighth Printing, 2007

Caren Caraway was born into a family of architects closely associated with Frank Lloyd Wright for four generations, and lived at Taliesin during her early childhood. A graduate of the Art Institute of Chicago, she has continued to work widely with a number of different media, including painting, photography, drawing, printing and writing. As designer and co-owner of Greenbriar Papers, she has marketed her stationery and print designs to a nationwide audience, and her paintings have been exhibited both in the United States and in India. Several times she has traveled to Mexico and the Central American countries to visit sites and museum collections. She has been to Panama four times - twice to the San Blas Islands - and each time has studied, with growing fascination, the molas produced there.

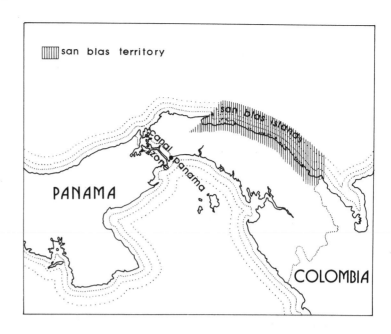

Introduction

BAB DUMAD, CREATOR AND ONE GOD of all the universe, gave to the Kuna people a favored climate of bright sun, cooling winds and abundant gentle seas which nourish palm-covered islands of coral sand and verdant mainland jungle.

Then, through his prophet IBÉ-HORGUN, he told them how to live a good life, in harmony with the physical and spiritual realms.

IBÉ-HORGUN gave the Kuna their culture, language and names for objects. He proclaimed the virtues of graciousness and cooperation, and honor to the elders. He dictated which work was to be done by women and which by men. He taught the men how to build houses, cultivate crops, fell forest trees, make household utensils and fabric. Women were to prepare the food, clean the clothes and tend the maize. IBÉ-HORGUN fashioned the first nose rings, instructed the people in ways of dress, and taught them to sleep in hammocks. He chose the sites for the placement of villages. He instructed the Kuna in the service of God, and he revealed to the medicine men the secrets of healing plants and chants; as well as the use of carved dolls and sticks, made from special trees and given power by eight days of singing. He told them how to cast out devils with song and incense, and how to chant for the protection of the soul of one who has died. He initiated the puberty rites for young girls, and prescribed the ritual ceremony that strengthens the inner visions of the NELES, and those clairvoyants born with BAD DUMAD's gift of "special eyes and special minds." And he showed how the Spirit of the Arts, which lives in the Sappi Karta Sakkan tree, could be transferred to a woman, when she applies a potion made from its magic leaves to her eyes and forehead, in order to become a maker of magnificent molas.

Most of the 26,000 Kuna live clustered on fifty-two of the 365 tiny San Blas Islands which dot 100 miles of Panama's Gulf of Darien. A long coral barrier reef, which protects the Islands from the surging Caribbean Sea, has provided a beautiful environment for the Kuna since the mid-19th century, when they migrated from the Darien Peninsula.

Remembering the atrocities of their 300-year-long struggle against the Spanish colonists, the Kunas have used their relative isolation and exclusive ways to resist foreign influences, thus maintaining their cultural heritage and racial purity. They have not married outside the tribe, and until recently no foreigner was allowed to stay overnight under penalty of death. Babies of doubtful parentage were not allowed to live. "Moon children" were also sometimes put to death at birth. Extremely short and generally brown-skinned, the Kuna produce the world's greatest percentage of albinos.

In 1925 they rebelled against Panama and proclaimed themselves an independent state.

Their society is now autonomous, although their territory is part of Panama. They developed a basically matriarchal society in which men and women fulfill definite roles, although the men dominate Kuna life. They are the heads of the family and chiefs of the islands. Certain men undergo many years of apprenticeship before assuming the life-long duties of chief or one of the four types of medicine man. The chief presides at the meetings of the Congress, reminds his people of their religious and historial traditions, and tries to maintain peaceful social behavior. The medicine men have special work dealing with the supernatural causes of illness. They use herbs, chants and medicine idols—dolls and staffs carved from different woods, in which good spirits reside.

All men are members of the Congress, which meets almost daily to discuss business and delegate daily activities. It is the man's responsibility to harvest crops from the land and fish from the sea, after receiving work assignments from the male head of the clan. Long before they marry, they plant palms, a gift from God, on the mainland and islands, which will provide a bountiful supply of coconuts by the time they wed and raise families. The coconuts are used in place of money, and most are sold to Colombian boats, which buy thousands at a time for 25¢ per coconut.

Other crops, such as bananas, cocoa, sugar cane and rice are planted on the mainland in small jungle plots that are cut, left to dry for several weeks, then burnt and planted. The area is used for one year, then left fallow for ten to twenty years. The mainland also provides all firewood and wild animals for hunting.

Much of the work is done cooperatively. The agricultural work day begins early in the morning and ends by noon. The men also build and repair the houses, which have thatched roofs and windowless cane walls fastened together with vines. They carve wooden staffs of office, household items and kitchen utensils. Some dugout canoes last for forty years. In their leisure time they weave baskets and fire-fans, and discuss tribal affairs. It was traditional for the men to make clothing for themselves and their sons, but now most is store-bought.

Some Kuna men travel the world, working on foreign ships, and many work for fixed periods of time in the Canal Zone. There they learn some English, in addition to the Spanish they learned in the schools which exist on more than half the Islands.

But the women are forbidden to go outside of the Territory. They are to remain on the Islands, where they own and inherit the property which the men work, and raise their families.

A girl child is preferred over a son, because she brings a son-in-law into the family. When she reaches the age of puberty, the event is celebrated with great festivity and ritual. At the age of sixteen or seventeen a girl can choose a husband, who may not always be consulted. He may be kidnapped in the marriage ceremony and thrown into the bride's hammock for three consecutive nights. If he then agrees to the marriage by cutting down a tree and bringing the log to his mother-in-law's fire, he must live with and work for his wife's family until the death of his father-in-law, or substitute money for service. Even if he is divorced or becomes a widower, his children remain in the extended family.

Under the guidance of the head woman, the women do the housework, cooking and laundry. They tend the children and fetch fresh water from mainland rivers. Then, in their spare time, they make molas, often working at night by the light of a kerosene lamp.

"Mola" originally meant cloth, but the word now describes both a blouse and its individual panels. Each panel, one in the front and one in the back, is an intricate, brilliantly colored design worked in several layers of cloth. It is part of the distinctive costume of the Kuna woman, which also includes a blue print wrap-around skirt; strings of yellow and red beads tightly wrapped around her legs and arms; a gold nose-ring, large earrings and a pectoral; necklaces of coins, beads, teeth or shells; a black beauty line painted down her nose; and short cropped hair, which is often covered with a red-and-yellow printed scarf.

Kunas revere artists, and believe there is a special place in heaven for them. Kuna women

are artists who have been creating ever since they long ago profusely painted their bodies with red, yellow and blue-black pigments for protection against evil spirits. Body-painting may then have developed into fabric painting, for by the late 1880s, Kuna women wore hand-painted loincloths and underskirts under knee-length shifts. By 1890 or 1900, when more colorful cotton fabric, needles and scissors were offered by coconut traders, the bottom band of the shift was decorated with simple appliqués. This was widened from hem to armpits, but soon the costume changed as the women adopted wrap-around skirts; so appliqué was used only on the blouses. Shells, beads and mirror fragments were used on those early molas. Then, when they were entirely appliquéd, they were made from just two colors, red and black or orange and black. Later, a third color was added. Now molas are made with many colors, although red and black are still the favorite colors.

The average size of a mola is 16″ x 19″, and months can be spent securing the layers with minute stitches. The basic steps for constructing a mola begin when two to seven layers of fabric are stacked and basted. The design is then visualized or drawn on the top piece. The largest design elements are cut out and the edges folded under and stitched down, to reveal the colors of the lower layers or pieces of additional color that may be filled in between layers. Smaller features are cut from the layers as the process continues. Final details may be added with appliqué or embroidery, as all large areas of single color are broken up and filled with smaller shapes and lines. Generally solid-color fabrics are used, which are now purchased in Panama City for $2.50 per yard. A spool of thread is 50¢.

The mola-maker believes all things contain a spirit, and so must her mola. The designs come from what she sees in her mind, her religion, her environment. Birds, animals, sea-life, insects, plants, religious scenes and legends, everday activities, letters and symbols from posters, ads and labels, are worked into fanciful patterns. Some are completely abstract. Certain mola designs have been handed down from mother to daughter for generations; but a design is never repeated exactly. Similar patterns in front and back blouse-panels will always vary in color or placement of shapes.

All of the Kuna women make molas from the time they are young girls, and those made "with good hands" are creations of marvelous artistry and technique. They are true works of art.

C.C.

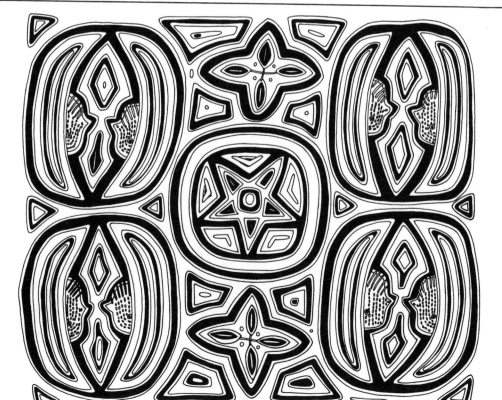

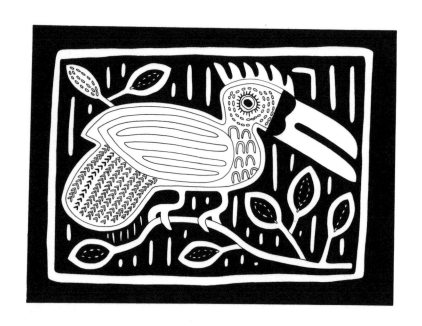

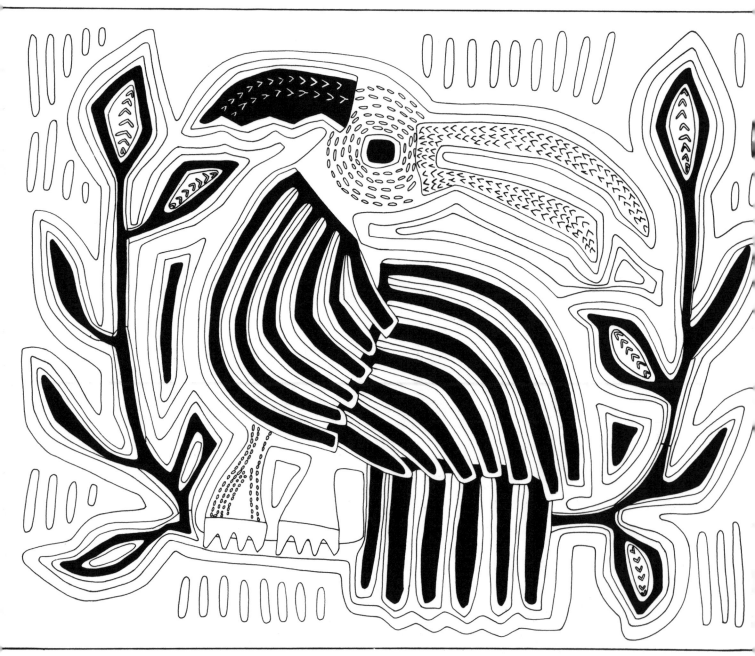

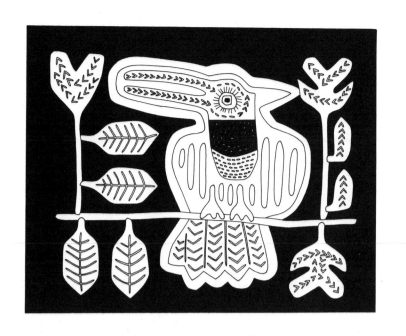

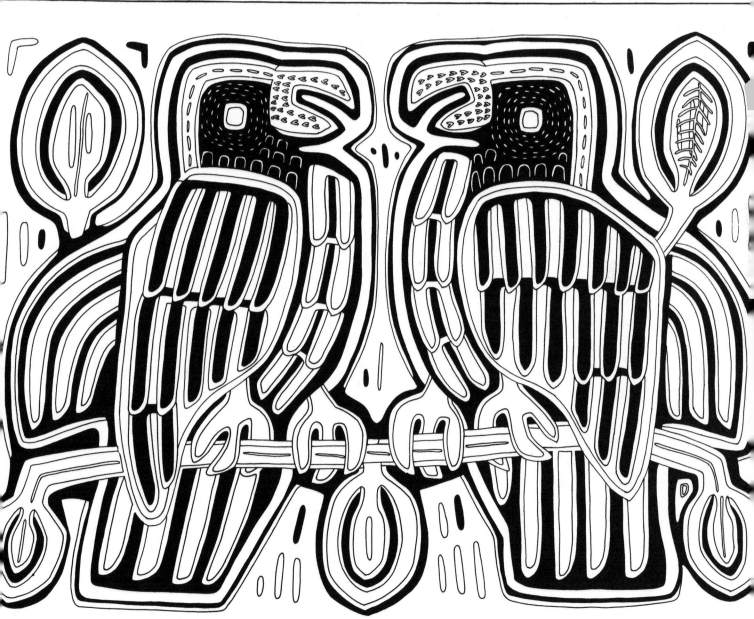

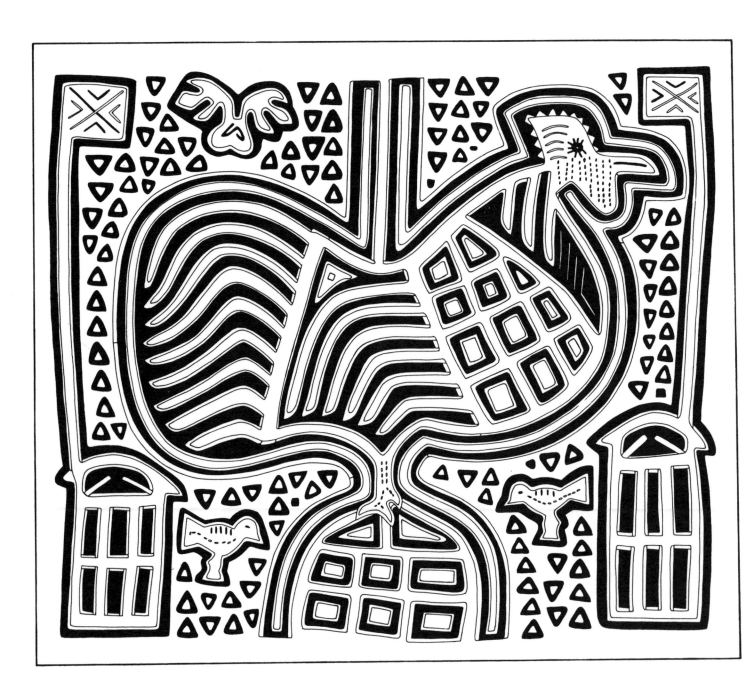

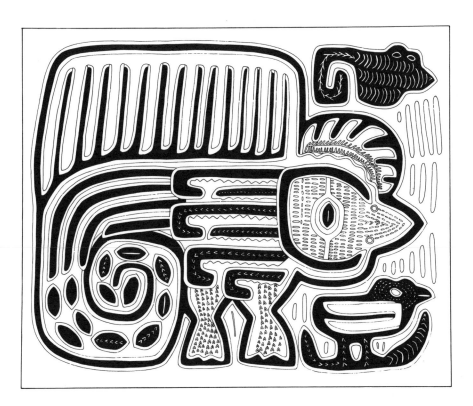

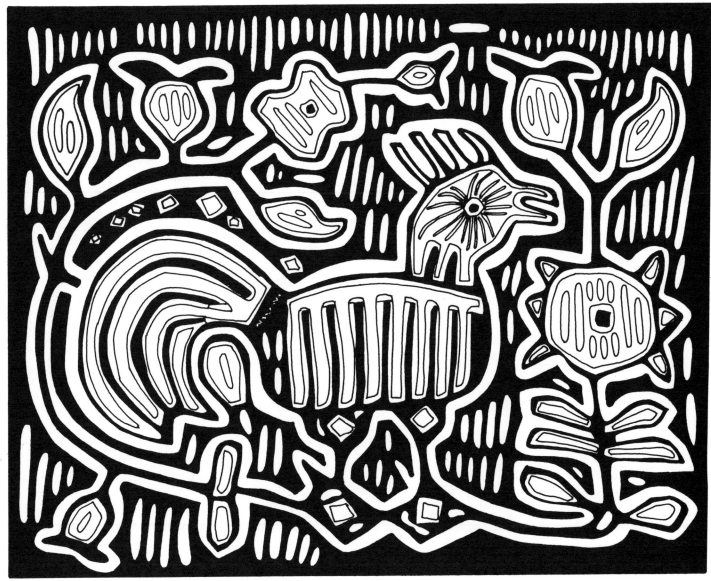

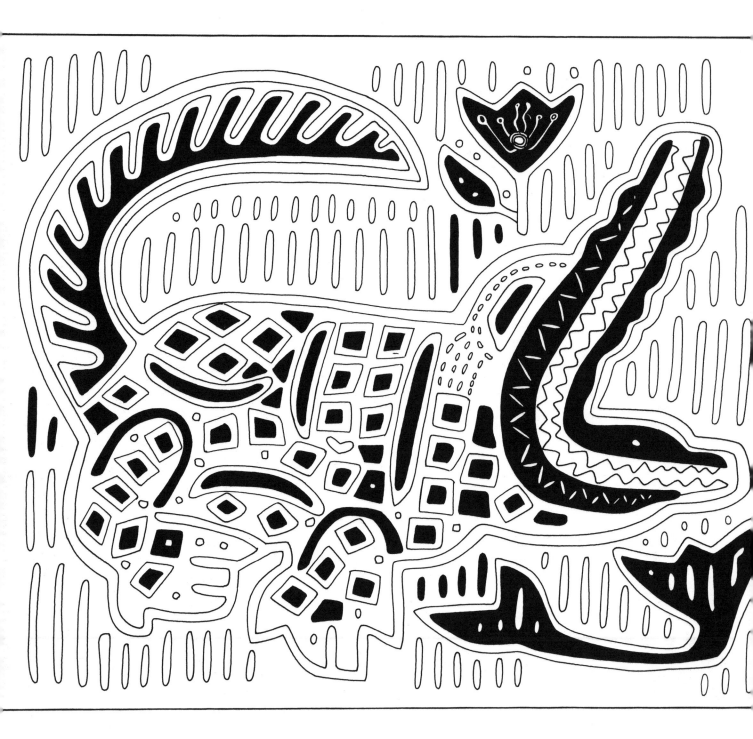

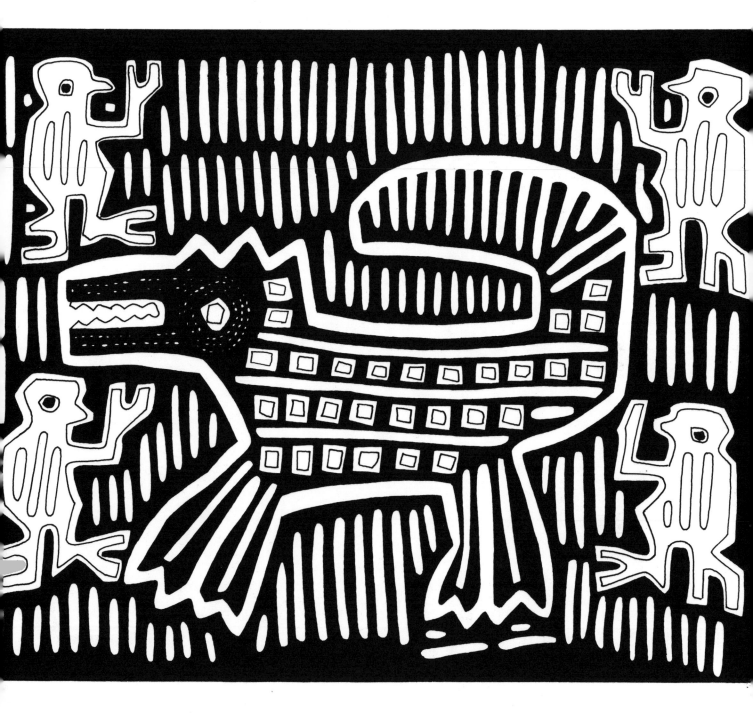

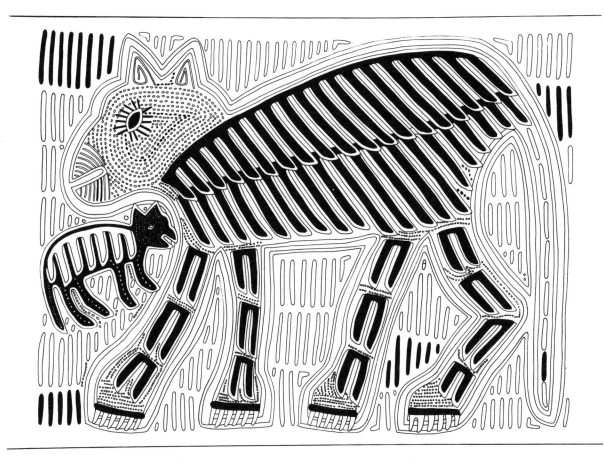

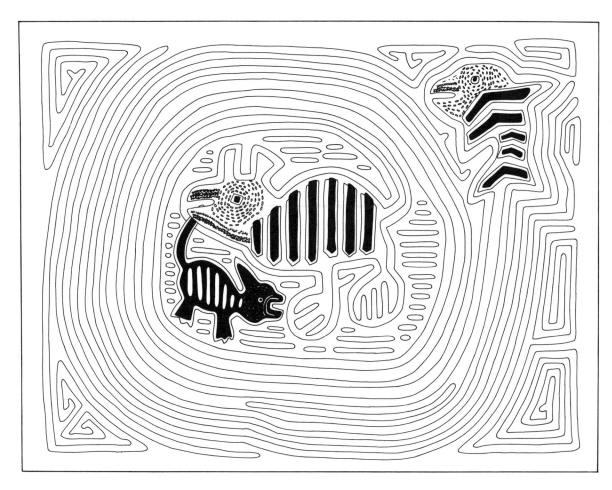

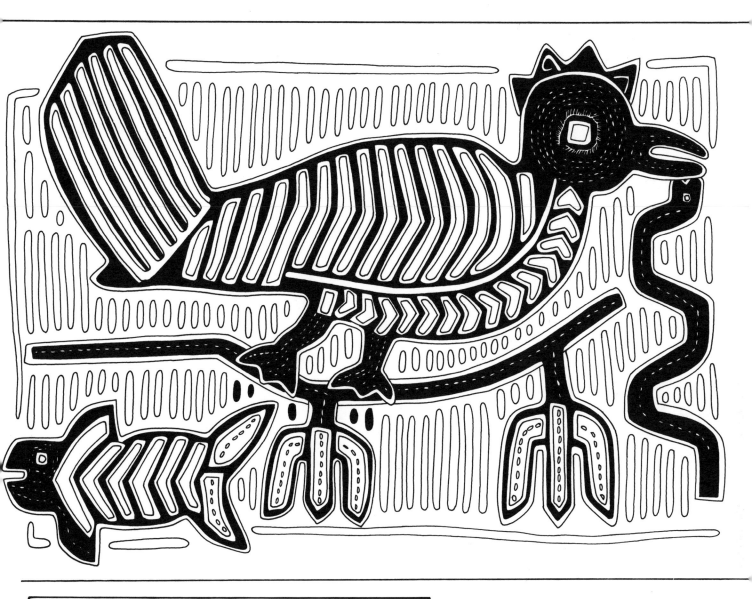

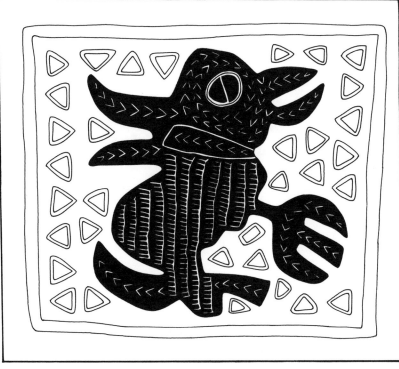

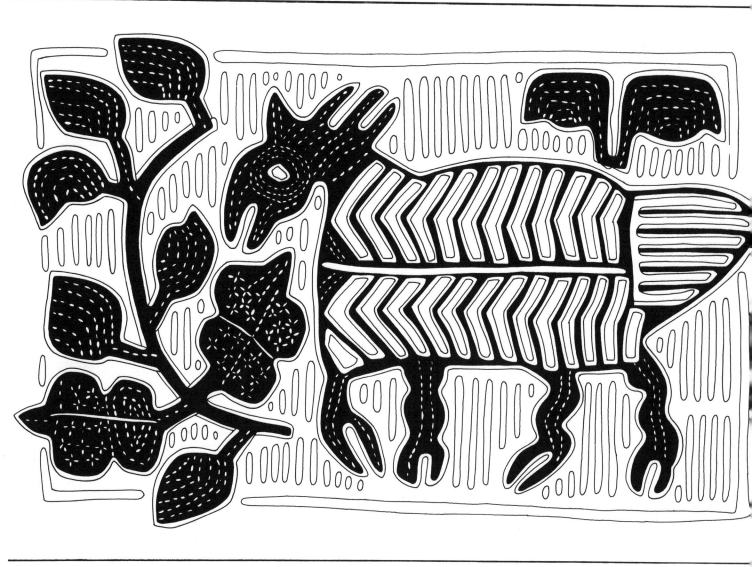
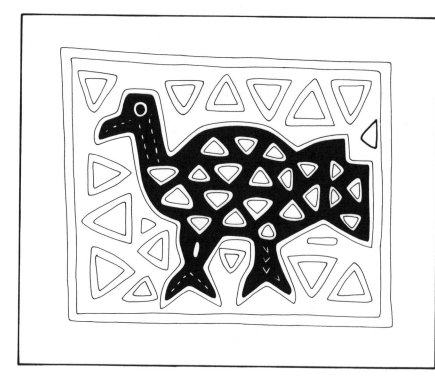

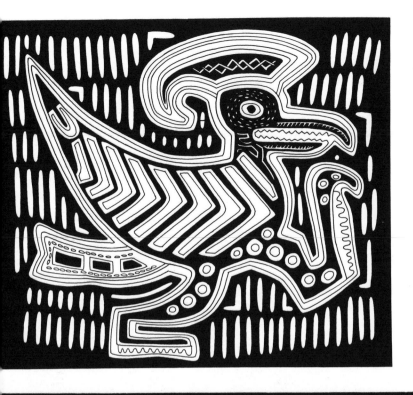

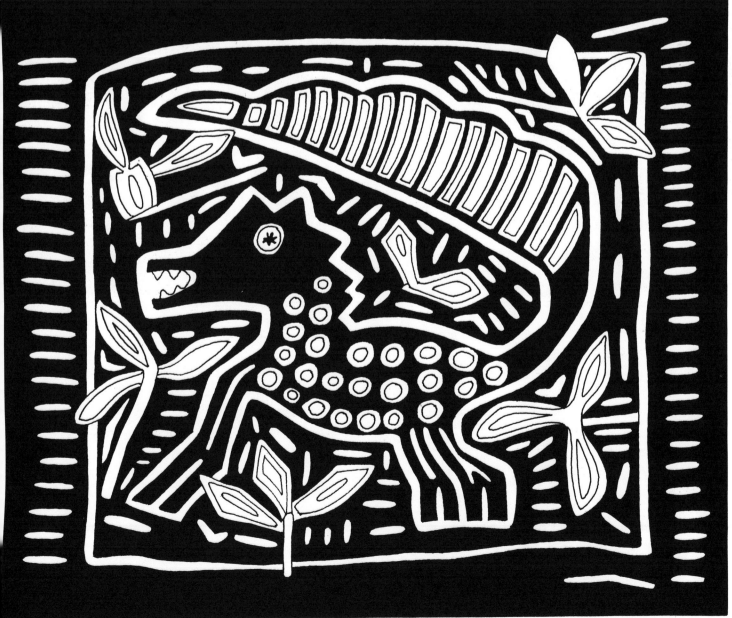

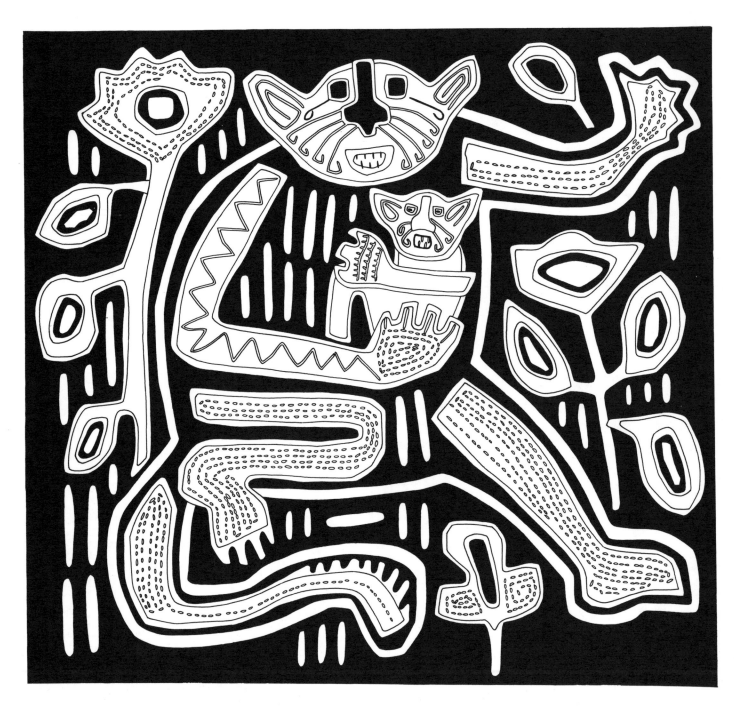

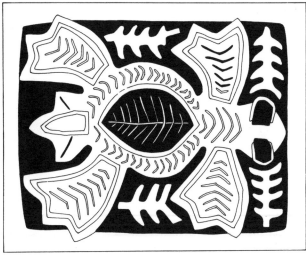

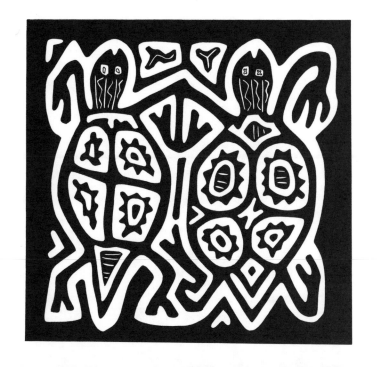

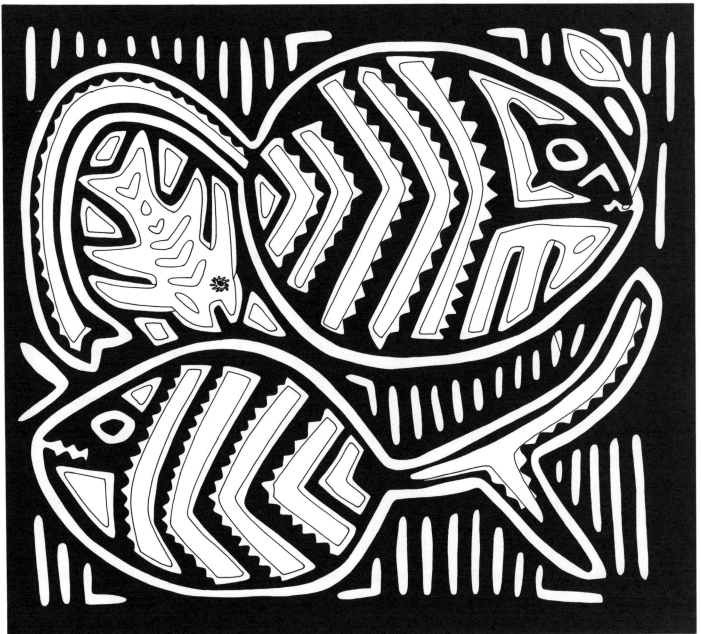

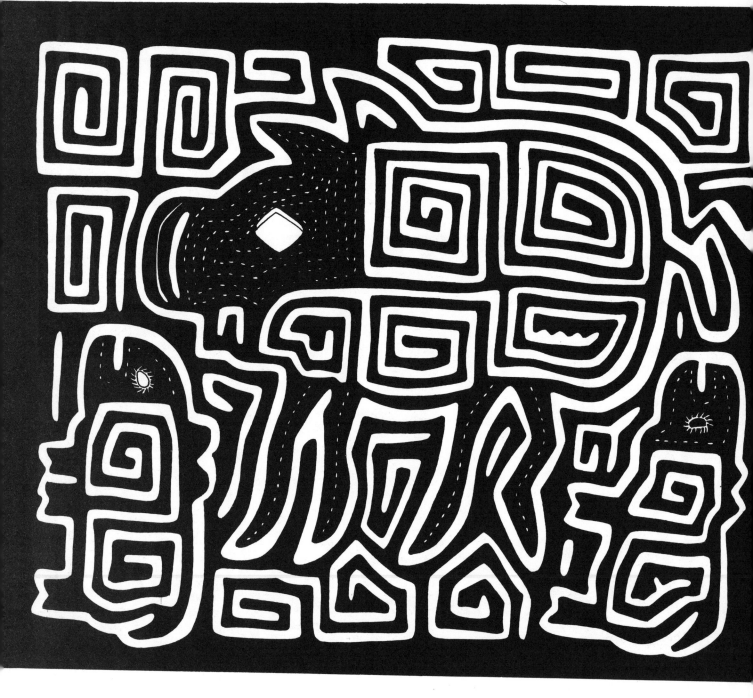

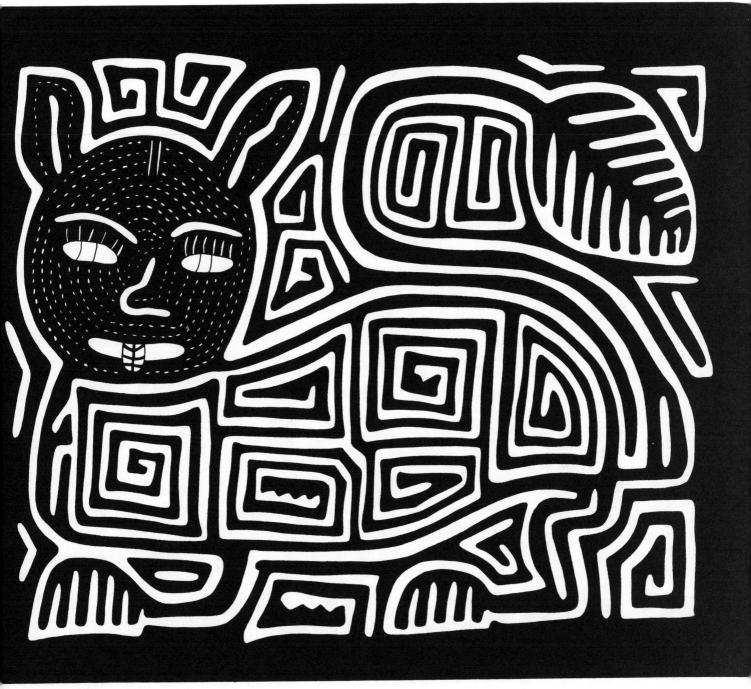

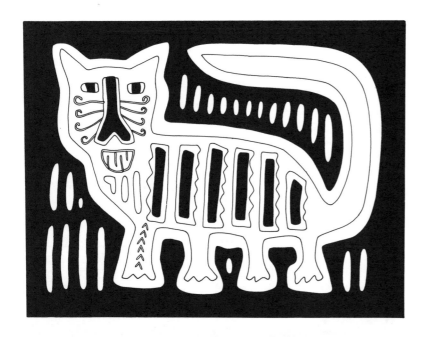

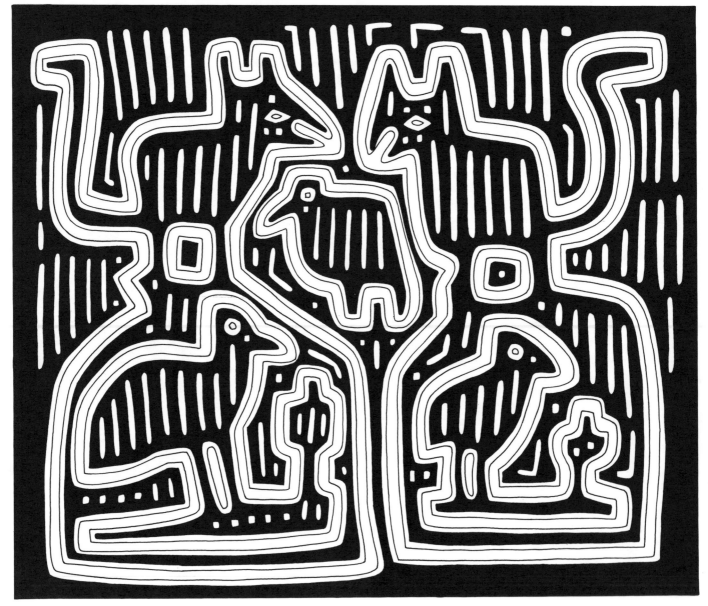

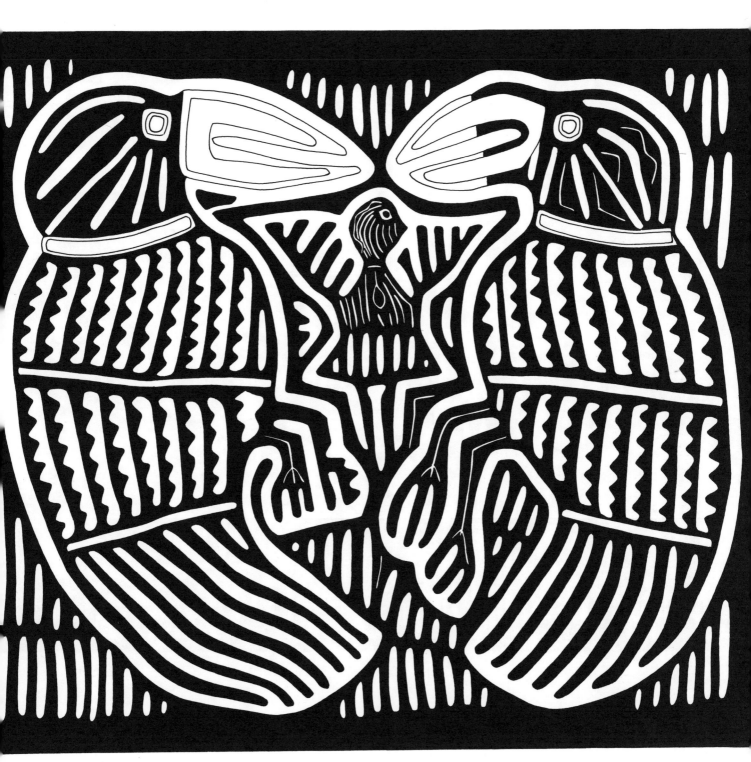

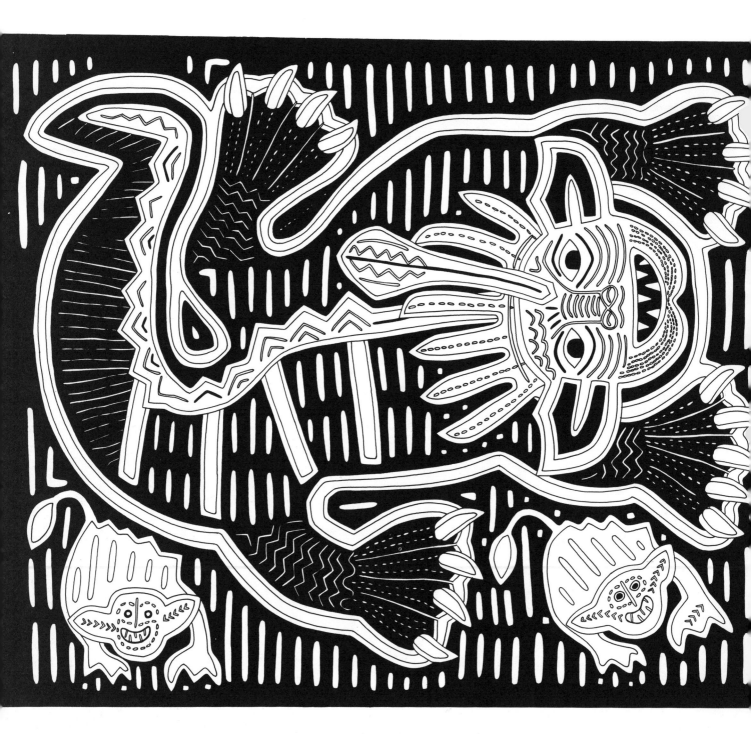

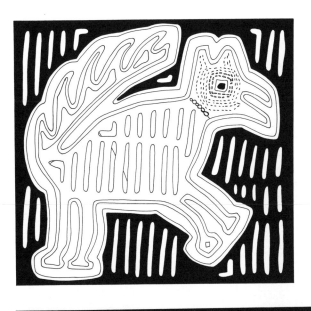

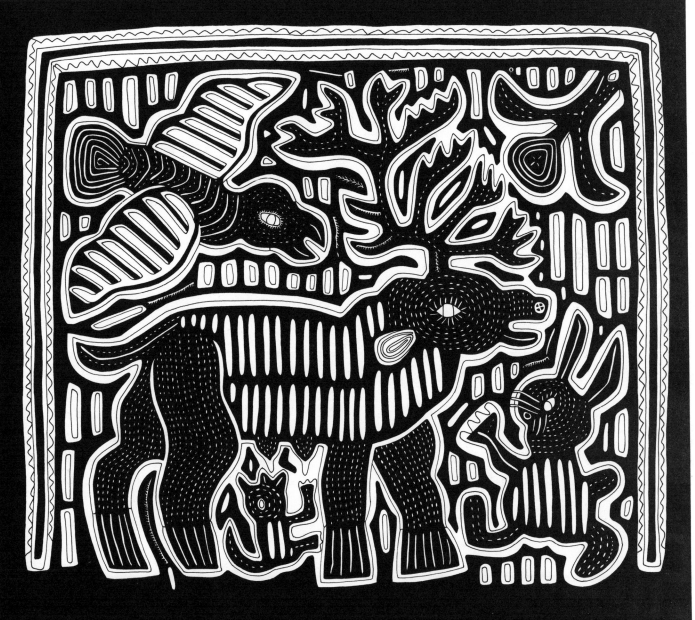

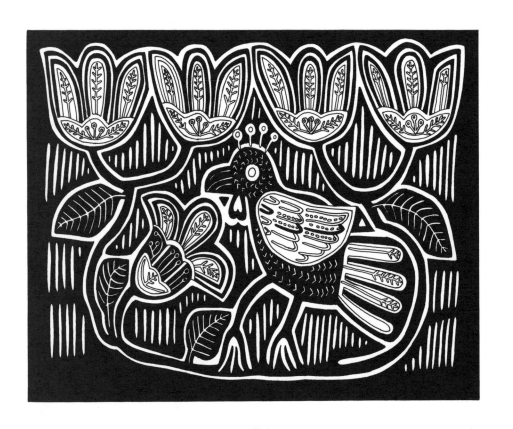

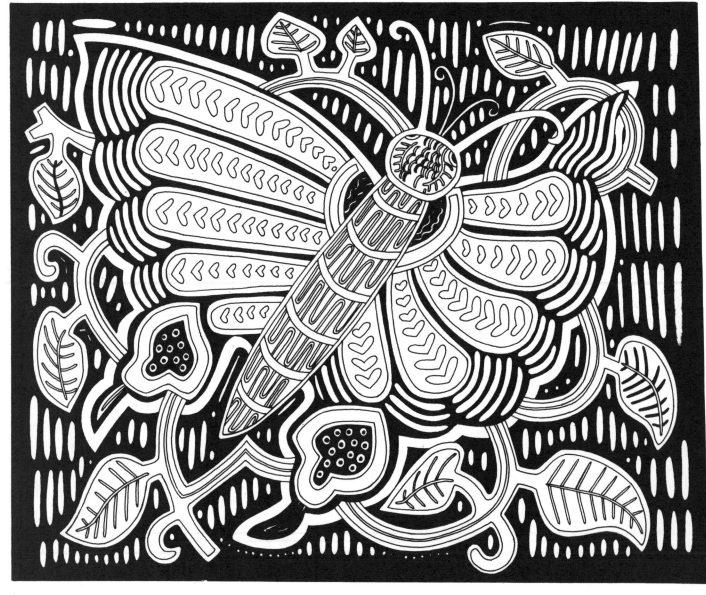

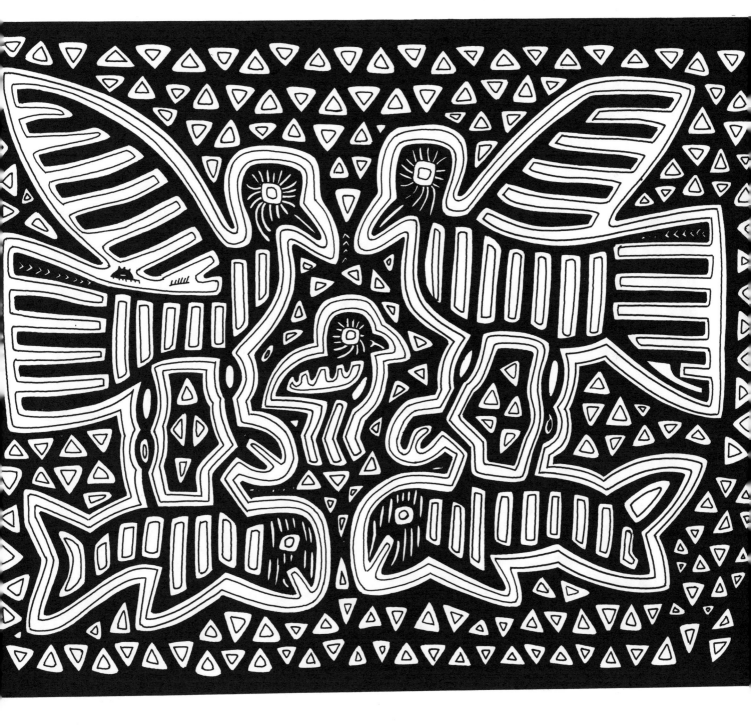

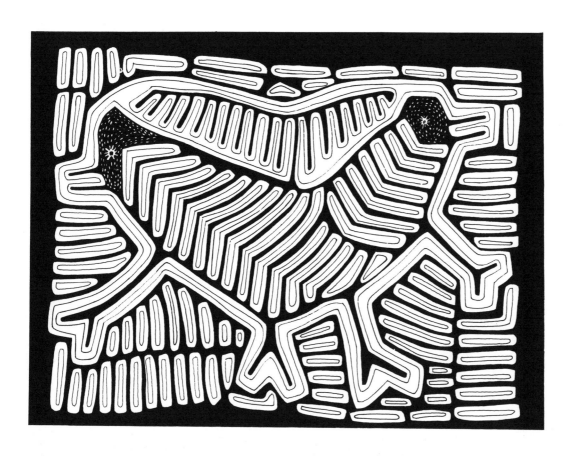

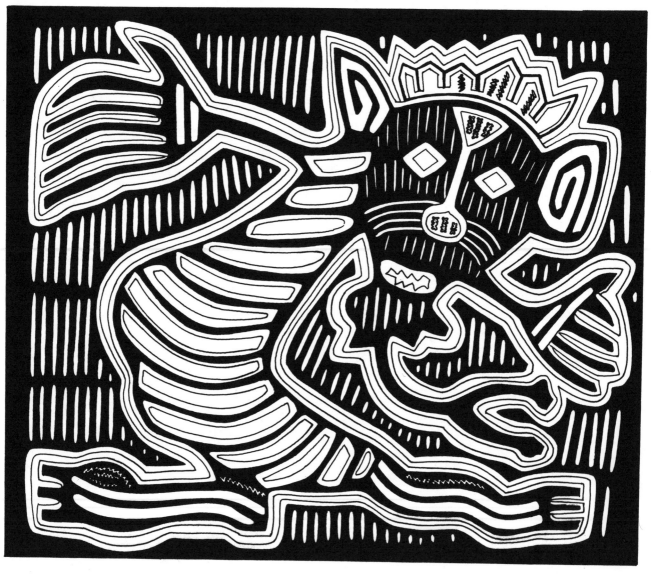

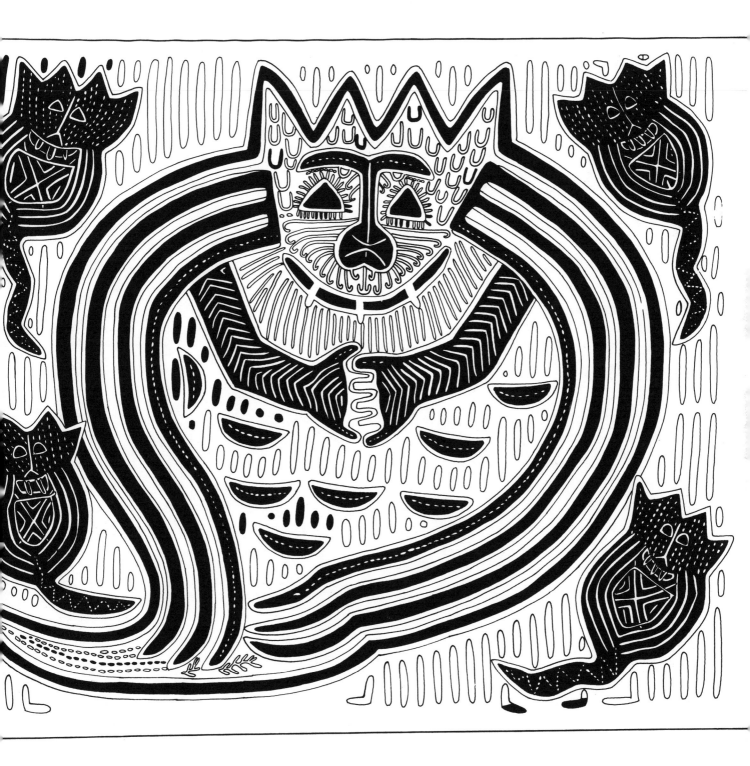

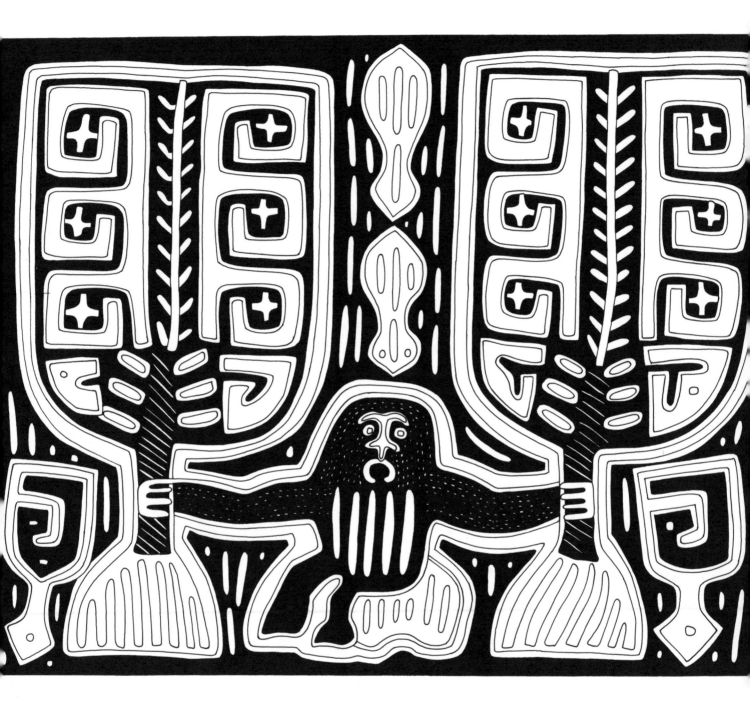

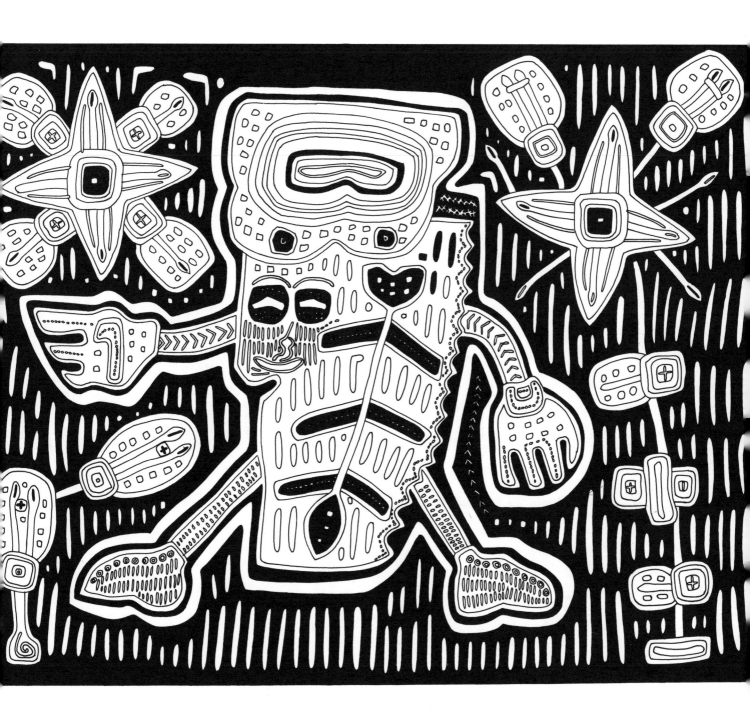

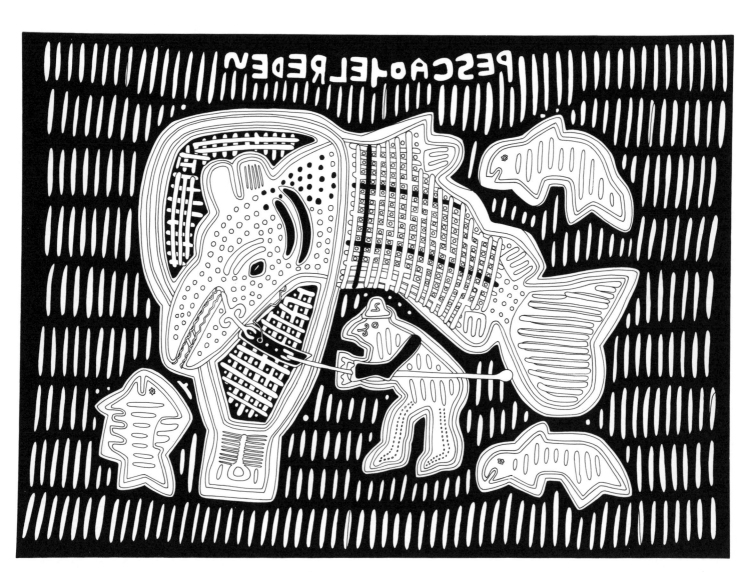

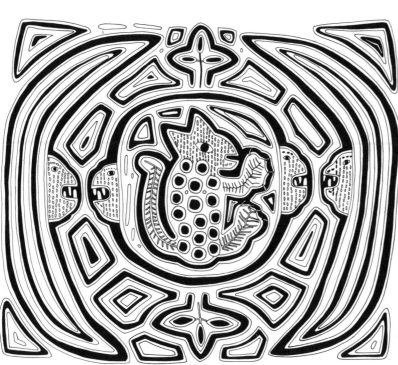

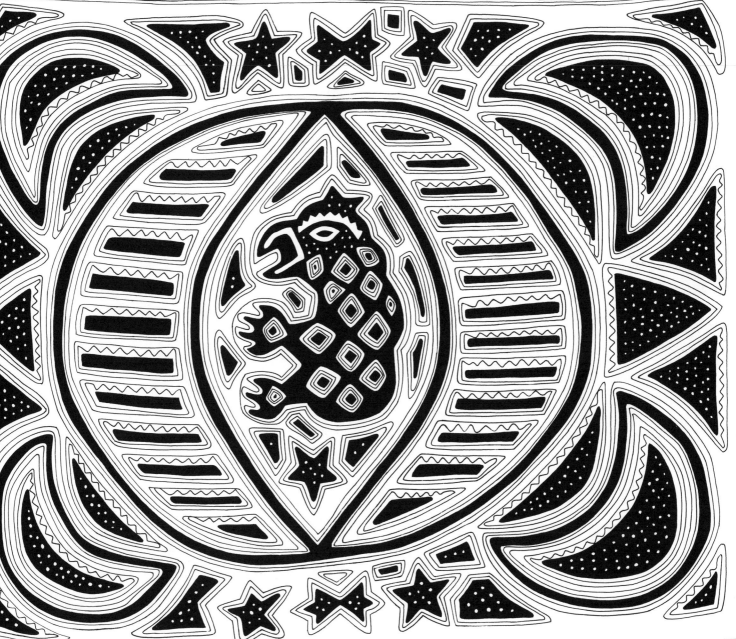

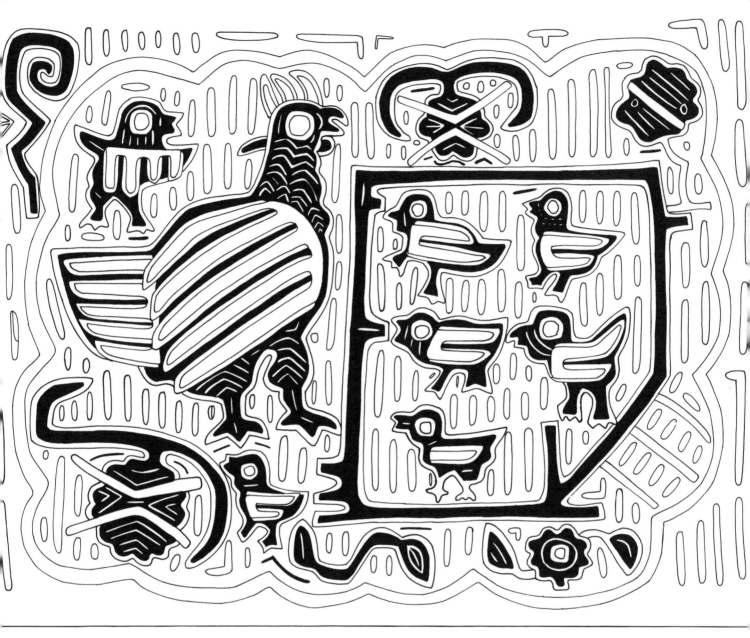

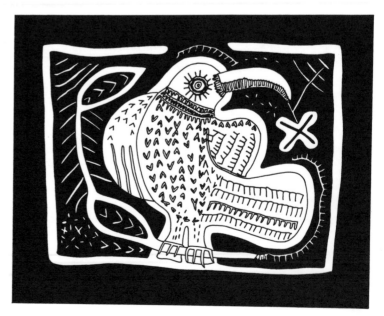

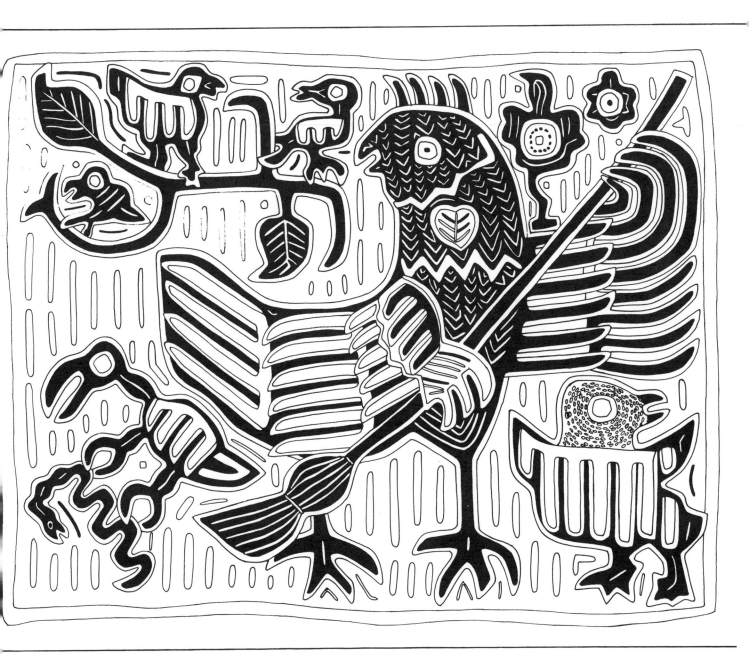

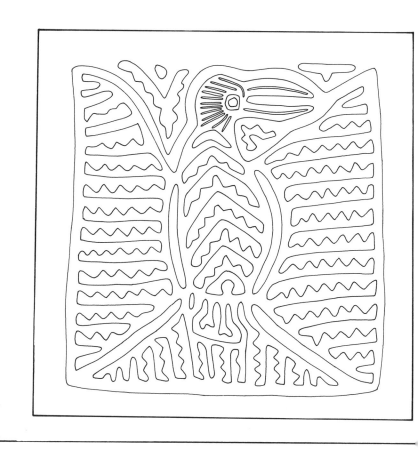

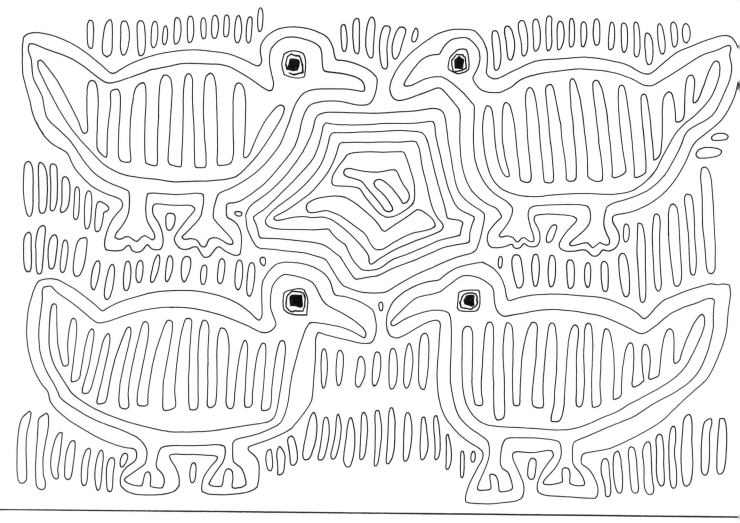

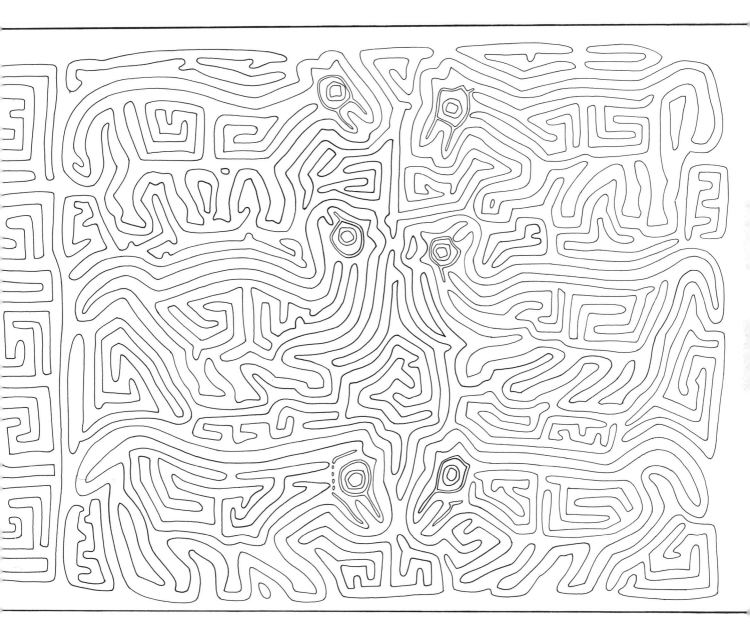

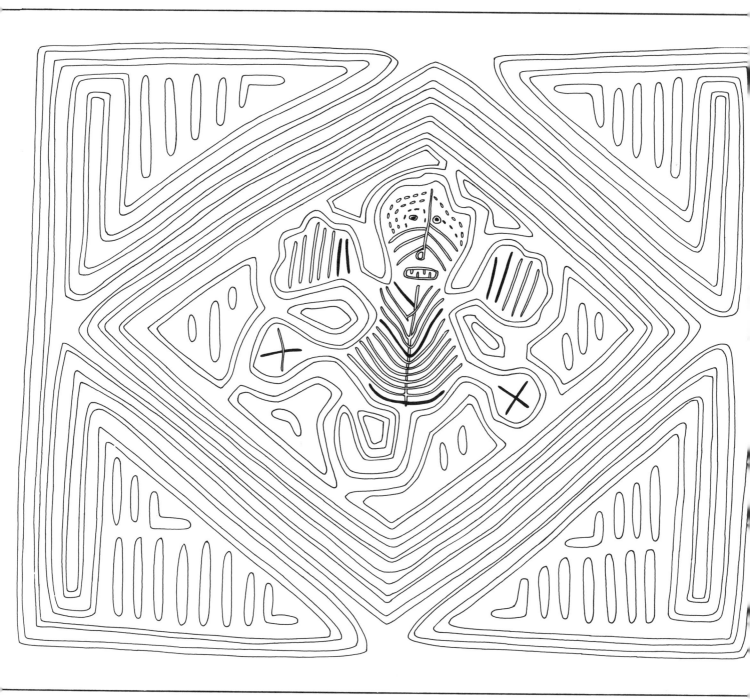

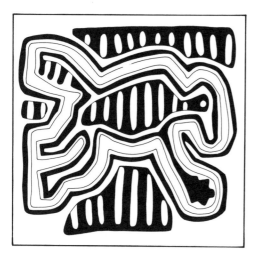

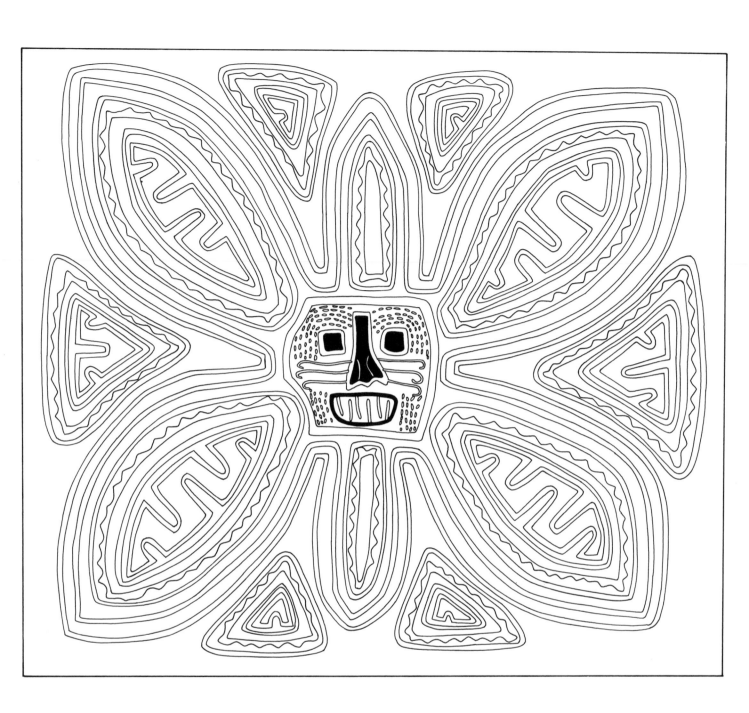

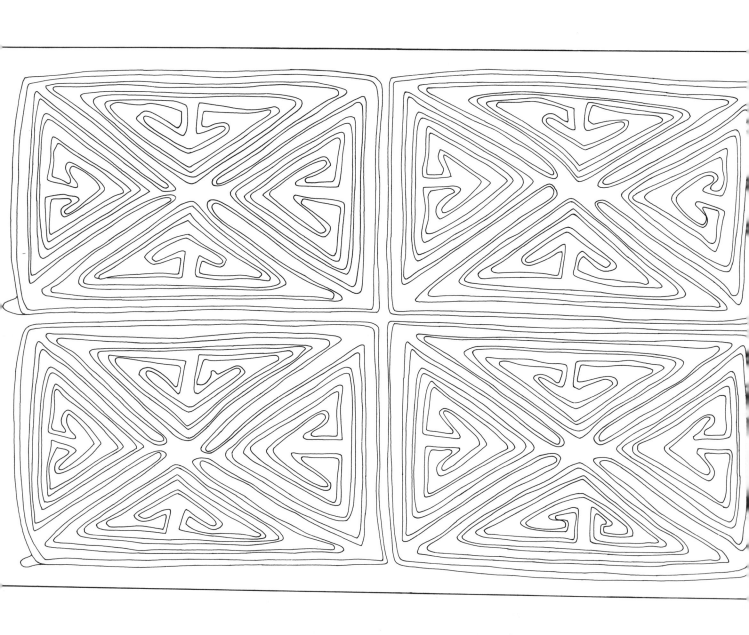

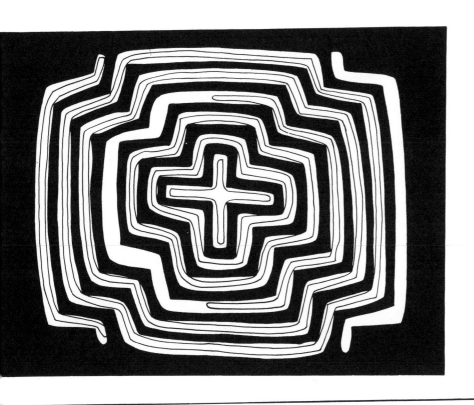

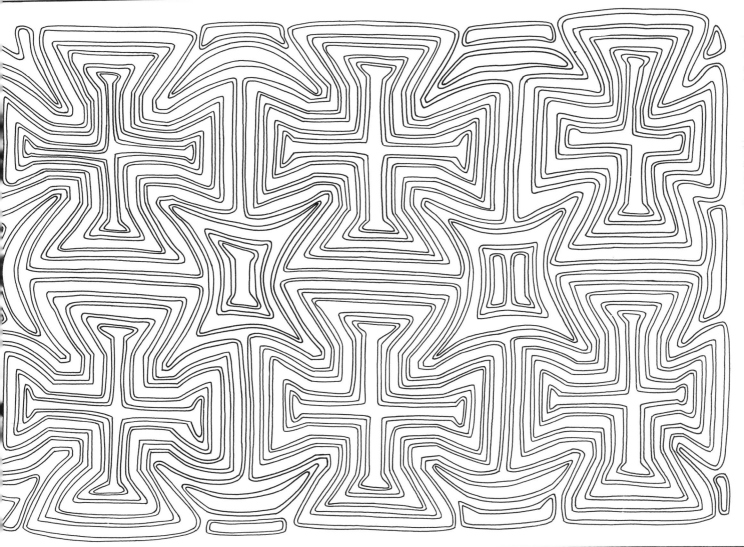

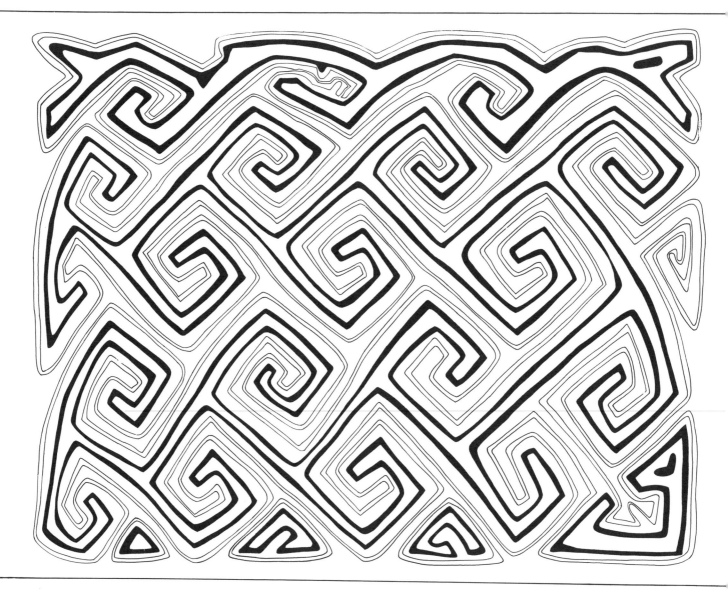

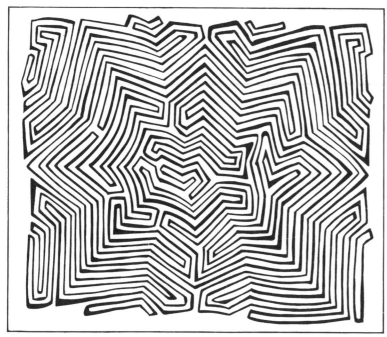

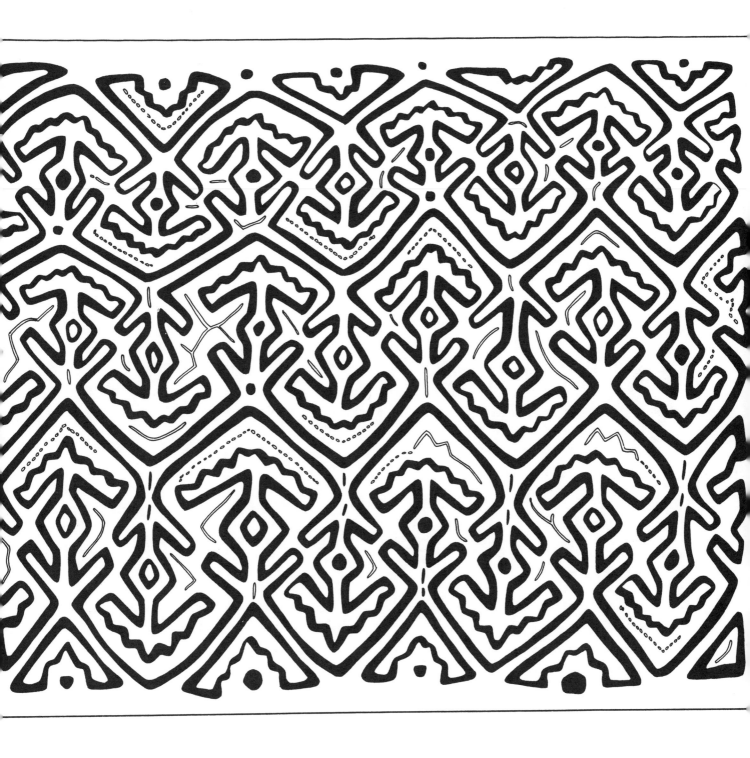

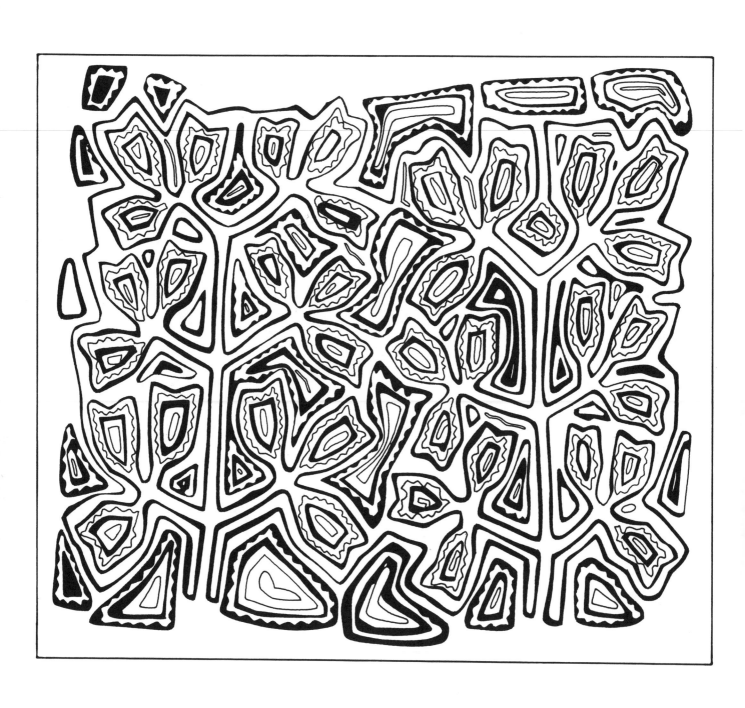

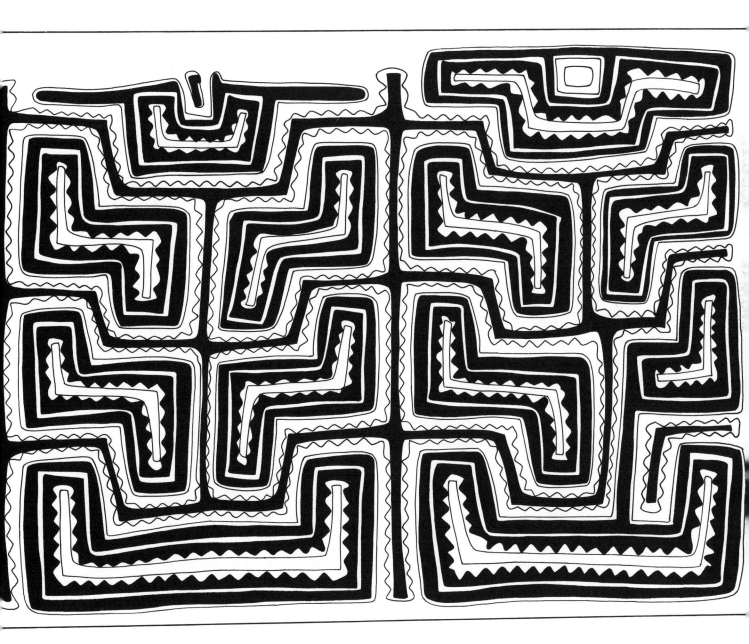

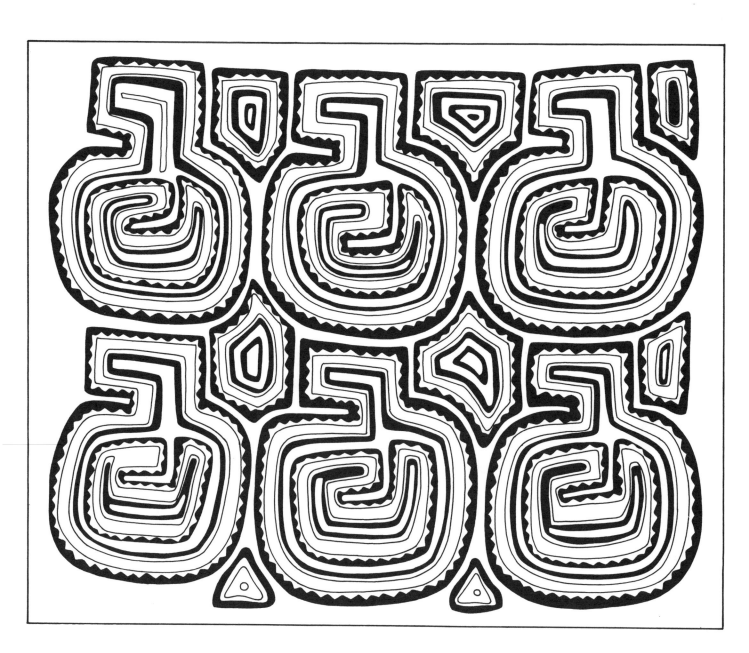

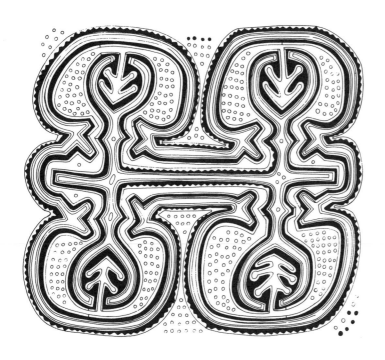

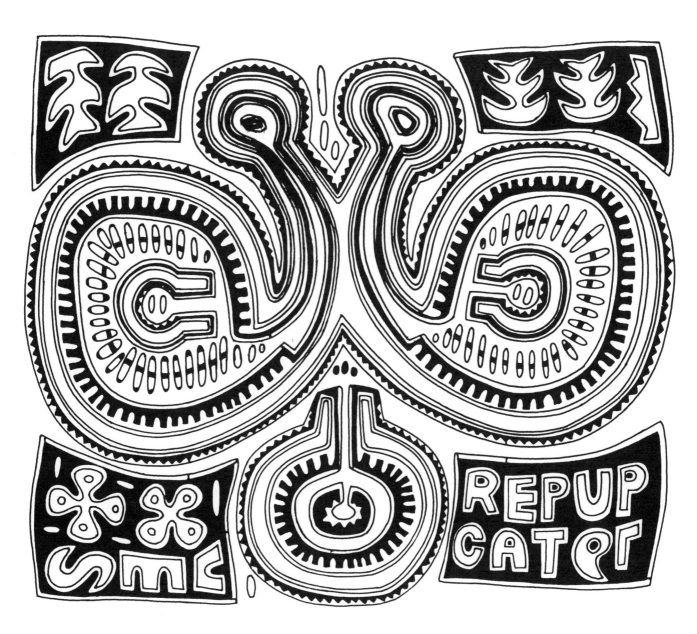

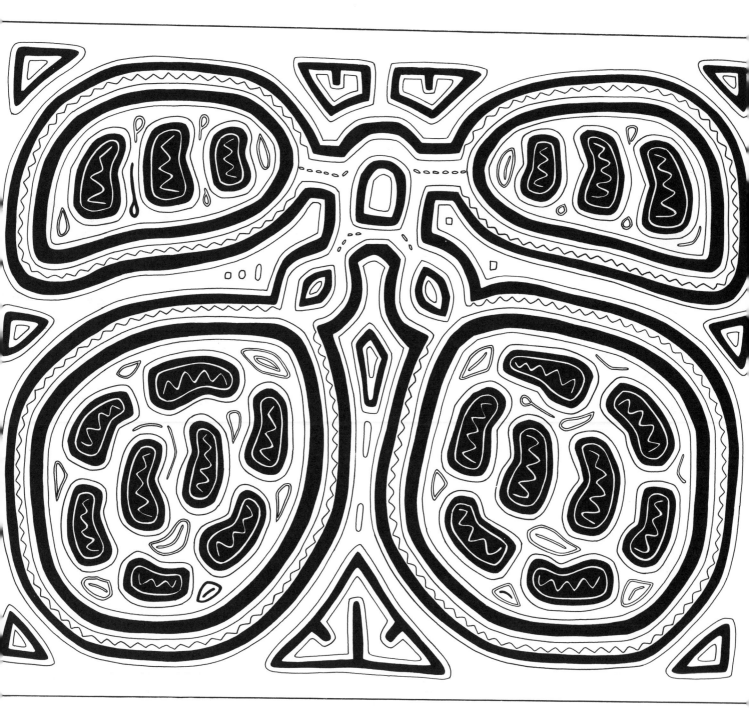

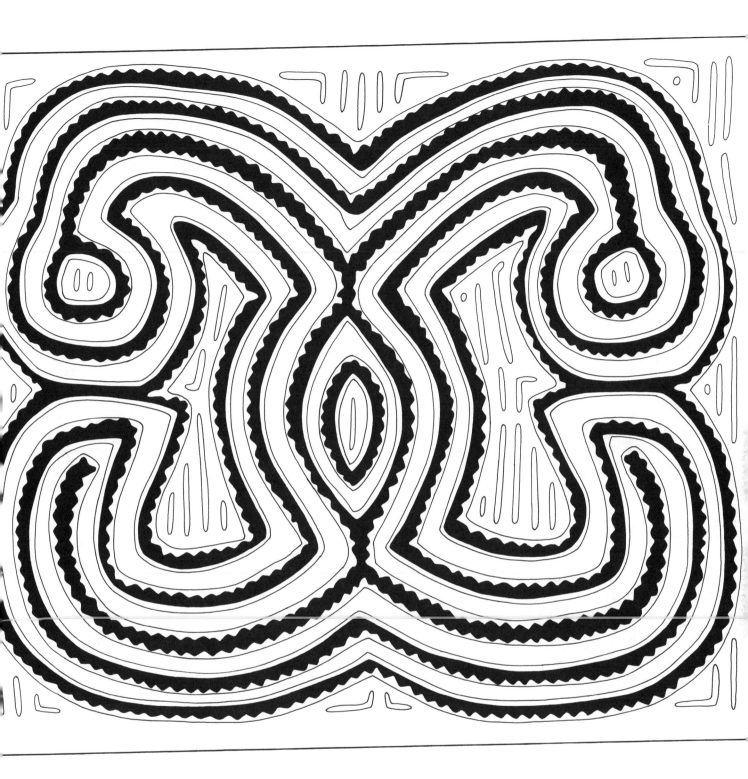

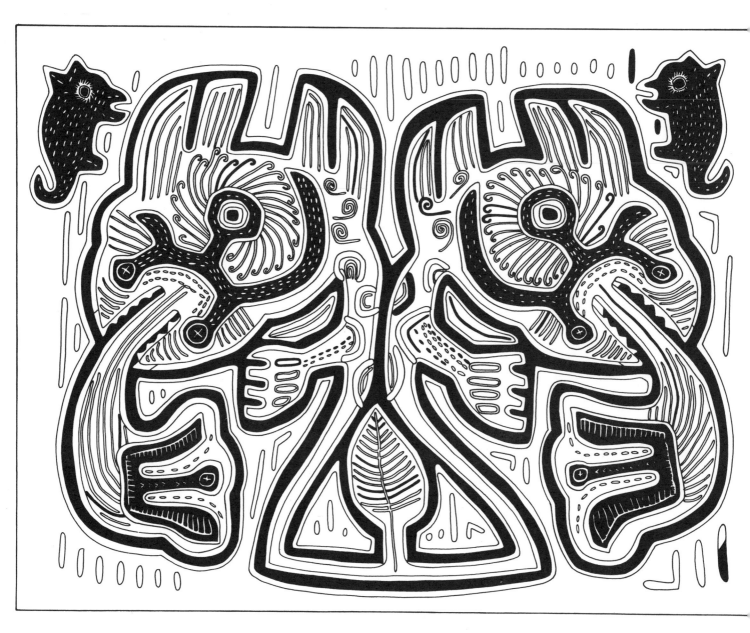

NUEDI Thank you

Elizabeth Bungay of London and Panama
Doug Reimer of Canada
Fabio Bethancourt of Panama
Fernán Soto Picado of Costa Rica
Violeta Kelertas of Wisconsin
Frank Dameron Leach of Wisconsin

And most especially
Alejandro "Henry" Harrison of the San Blas,
a marvelous, generous Kuna whose guidance
and knowledge helped make this book possible.

DEDICATED

To women artists everywhere, and the
Kuna women in particular, who continually
contribute works of art to all the people
of the earth while creatively fulfilling
other roles.

Colophon

Designed by Barbara Holdridge
Composed in Times Roman with Venus Extra Bold display
 by Brown Composition, Baltimore, Maryland
Color separations by Sun Crown, Washington, D.C.
Printed and bound by United Graphics, Inc., Mattoon, Illinois